Trevor Winkfield's Pageant

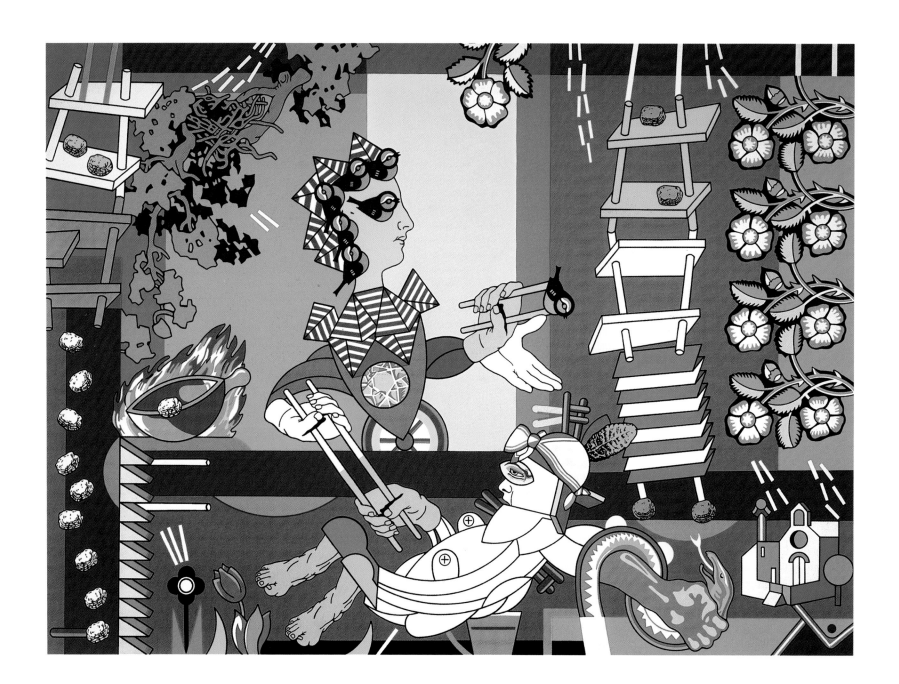

Trevor Winkfield's Pageant

Text by Jed Perl

Introduction by John Ashbery

Hard Press, Inc.
West Stockbridge, MA
1997

Cover: details from *The Painter and His Muse*, 1996

Designed by Jonathan Gams and Trevor Winkfield

Photo credit Zindman/Fremont

Drawings within the texts are taken from collaborations with Ron Padgett (*How to be a Woodpecker*, Toothpaste Press, 1983 and *How to be Modern Art*, Morning Coffee Chapbooks, 1984); Harry Mathews (*The Way Home*, Grenfell Press, 1988); and John Yau (*Piccadilly or Paradise*, Ferriss Editions, 1995). *With A Thrust of The Pelvis, I Become Woman!*; *The Mermaid's Revenge*; *A Winter World* and *Trapping Birds and Bees* are in the collection of A. G. Rosen, Wayne, N.J. *Voyage I* is in the collection of the Reinhold Brown Gallery, N.Y. *Tripoli* is in the collection of Peter Gizzi and Elizabeth Willis, Santa Cruz, CA.

The artist's work is represented by the Tibor de Nagy Gallery, N.Y.

Frontispiece: *With A Thrust Of The Pelvis, I Become Woman!*, 1996, 47 1/2 x 64 1/2", acrylic on linen

Thanks to patrons: the Dovydenas Family, Harry Mathews, Peter Straub, A. G. Rosen, Roger and the late Neil Barrett

Library of Congress Cataloging-in-Publications Data

Winkfield, Trevor 1997
 Trevor Winkfields Pageant / text by Jed Perl ; introduction by John Ashbery.

 p. cm.
 ISBN 1-889097-12-8 (alk. paper)
 1. Winkfield, Trevor--Catalogs. I. Winkfield, Trevor.
 II. Title.
 ND497.W715A4 1997
 759.2--dc21 97-28596
 CIP

Introduction

IF ALL ART ASPIRES toward the condition of music, as Pater wrote, Trevor Winkfield must be counted among the most successful artists of all time. A picture such as his great, recent *Voyage II* totally fulfills that condition: the accuracy and surprises of great music, even its linear unscrolling, are what confront us. In fact its effect is the same one a musical score offers a person with some ability for reading music — "sight-reading." Each element in the painting has its precise pitch, its duration. It's as though seeing and hearing merged in a single act, and the "meaning" of the picture were lodged at the intersection of two of the senses, where one is pleasurably enmeshed, deliciously hindered. The strange erection on the left — a toy windmill with dysfunctional looking paddles (isn't it from the coat of arms of some ancient and distinguished purveyor of something-or-other to the Royal Family?), firmly placed on a pedestal fashioned of bricks, tomatoes and other less namable objects, is there to cast the authority of its key-signature over the frieze on the right, whose elements include a harp, a seagull, some nautical-looking pennants, three table utensils tied together with a red bow, and at the far right some wave-like scallops and stylized drops of water that suggest the musical symbol for *da capo al fine* — go back and start all over again, you idiot! (One of the heroes in Winkfield's pantheon is Satie, author of a short piano piece called *Vexations* that is meant to be repeated 840 times.) There are also three identical hands, each one a different hue and each holding what may be an empty ice-cream cone (but the third cone has something attached to it that looks like a drooping slice of flan.) There are two sculptural heads, one Greek, the other that of a medieval bigwig, Charlemagne perhaps; both are gazing to the left (westward), where the music is coming from, and each is bathed in a different light, for which no source is apparent. These are the describable things, but there are less identifiable ones on which the same amount of objective care has been lavished: three-dimensional grids; stripes and colored lines; some stylized leaves at the top; and the Greek figure's curious torso, like a child's top. The colors are those of brand-new but antique toys that have been randomly stacked together: intense pastel greens, banana-yellow, vermilion, chartreuse, Tabasco red, Kool-Aid grape: an assembly whose components ought to "scream at" each other, but which are instead intoning something ineffable, some music of the spheres, though the spheres appear to be rolling around on the floor of a nursery rather than in the heavens.

One could go on listing and describing, "to small purpose and with less effect," in the words of Winkfield's friend, the late James Schuyler. What's clear is that there is no verbal equivalent for taking in the picture, just as there is none for assimilating a piece of music, which is as it should be. The experience in both cases amounts to what? Perhaps the very what in Jasper Johns' title *According to What*. Something is regulating everything and placing its parts in the proper relation to each other, but that thing is unknown: a blank, though a fundamental one. One reflects on how so much modern art is concerned with dropping things out: the momentous vacancies in Cézanne, in Cubist still-lifes, in Henry Moore's holes, in Giacometti's erasures. And how an equally important activity has been filling things up again: how the ashen, empty glasses in Picasso's 1910 still-lifes are brimming with violent-colored lemonade, Suze and cassis after 1914. Winkfield has somehow managed to combine both of these natural impulses to drain and to replenish, to build and to destroy. And he locates the core of creation precisely there, at the plimsoll line where the glass is both half empty and half full, where ecstasy means having exactly enough.

—John Ashbery

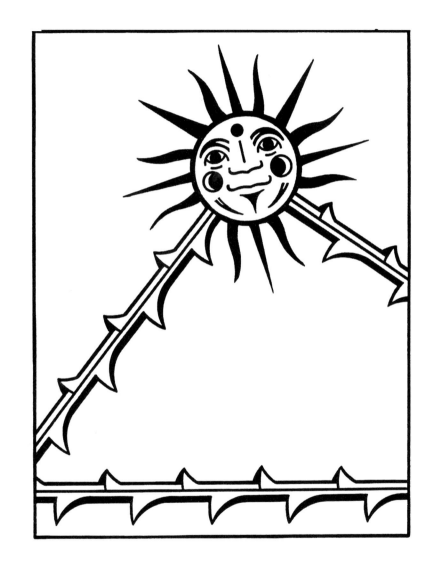

Trevor Winkfield's Pageant by Jed Perl

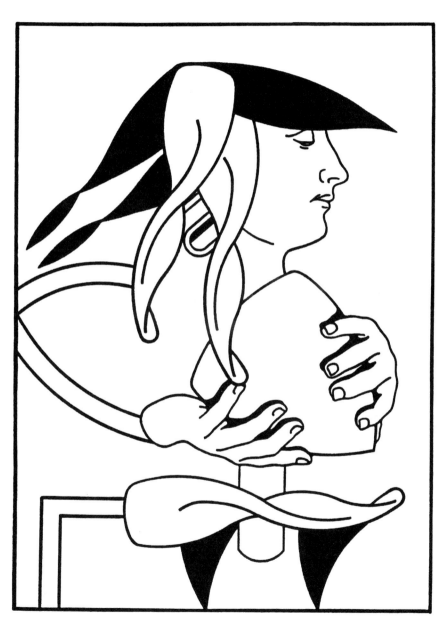

THERE HAVE ALWAYS BEEN ARTISTS who dreamed of reviving the elaborate costumes and stylized affections of the Middle Ages, and Trevor Winkfield, whose paintings are packed with absurdist heraldic devices, is one of the dreamers. Winkfield, who was born in Leeds in 1944, brings tough-mindedness to his whirling arabesques, and there's something ineffably English about the resulting combination of fantasy and precision; I find distant echoes of the delicate Lady Chapel in the fourteenth-century Ely Cathedral and the labyrinthine work of the nineteenth-century painter Richard Dadd. Using flat, crisply modern shapes, Winkfield imagines scenes from some zany toy theater and fills them with the elegantly florid patterns of a chivalric age. He's written that he still has vivid memories of 1953, the year of Elizabeth II's coronation; nine at the time, he was struck by all the "ceremony and religious ritual (particularly the handing over of regalia from archbishop to sovereign, and the hierarchical poses adopted by the sovereign when weighted down by this regalia)." The boy saw a modern princess transformed into a gothic heroine, and he probably saw it all filtered through the newsreel footage and crude tabloid images that were available in a provincial English town. It must have seemed as if medieval manners were zooming straight into the pop present, and that's exactly where Winkfield takes up the story.

Winkfield fills his paintings with court jesters, tournament props, and monkish hoods, yet this is also unmistakably the work of a modern man, who sees abstraction as a fact of life — a visual equivalent of a more general cultural disarray. He's basically attracted to medieval pageantry because it's an idealized order, and if his own post-abstract sense of structure leaves lots of room for upheaval and confusion, that's his way of measuring the distance that we've travelled from the time of *The Romance of the Rose*. What Winkfield understands is that the pomp and circumstance that may have been

a medieval reality have become a modern fantasy, and because he has such an intuitive feeling for that never-never land, his paintings, although chock-a-block with off-beat pedantry, aren't overly self-conscious. His exuberant color and get-the-job-done painthandling lend even the most labyrinthine imaginings a streamlined ease. We're able to glance easily over mysteriously antiquarian encounters. In Winkfield's paintings bizarre juxtapositions are everyday occurances. He's telling us that modern life is a crazy pageant.

Like much strong painting that's produced today, Winkfield's work suggest an ambiguous universe where naturalistic forms are reshaped by abstract forces. In his canvases the clash of apparently irreconcilable traditions has an underlying biographical meaning, because the artist, although born and educated in England, has pretty much become a New Yorker since moving here at the end of the 1960s, when he was still in his twenties. Thus while the nautical doodads and general air of Edwardian nursery room humor say "English" — and say it even to those who don't know Winkfield's story — the hard-edged, joyfully strident look of the paintings could be stamped "Made in USA." In Winkfield's canvases the old English eccentricity is reconsidered from the vantage point of mad Manhattan, and if his best paintings summon up a feeling of cheerful panic, how could it be otherwise? Winkfield is living in New York and contemplating somewhere — or something — else, which is a fairly common situation.

This is an art of cool surfaces and madcap subjects. Frequently, the central attraction is a figure, and there's something both touching and troubling about personages that are such odd amalgams of household objects and hardware and old-fashioned costumes. Winkfield's jerry-built humanoids call to mind eighteenth-century automata or avant-garde marionettes. They're ghosts who've ransacked the flea market for an identity, and the loopiness of the outfits is obviously a burden, a freakishly jolly carapace that must be carried everywhere. Winkfield's weirdos, in spite of their up-for-anything smiles, are ambivalent about the roles they play; it's overwhelming to be centerstage, or to bump into the strangest props when you make the slightest move.

Winkfield has said that among the key influences on his work he counts "the pinball machine effect of Duchamp's *Large Glass* — how one object leads to another, and in so doing activates it." His paintings have their own assembly-line-like absurdism; they're surrealist pinball machines. This painter loves sleek, machine-tooled forms, and he's creating a whimsical, cottage-industry version of mass production when he fills one painting with half-a-dozen or so identical forms — balls or wheels or matchsticks or cubes or mallets. Arranged at various odd angles, these rising and falling doodads create arcs and trajectories that take us on a twirling journey. The littered objects give some paintings a William Morris-like busyness, which Winkfield is often inclined to oppose to a backdrop of bold planes of color, so that the little incidents turn out to be neatly pinned down, like butterflies in a curio cabinet.

In several recent paintings the strong-willed nut case who's trying to call the shots is actually an artist. It turns out that putting brush to canvas is as good a way as any to cope with the maelstrom of emblems. In *The Painter and His Muse*, the birdlike painter works on his small seascape while the muse, equally birdlike, holds up a schematic plan of a sailboat. There's so much going on here that it's difficult to know whether the painter is in control or just soldiering on. A sort of chessboard that doubles as a palette may refer to

Duchamp, but I have no idea what to make of a group of forms that surround the muse; they look a bit like medieval halberds and a bit like the jacks that a boy keeps in the bag with the marbles. The artist who negotiates this unpredictable universe is a cross between an anonymous medieval craftsman and a character in a slapstick comedy. He's also a sort of harrassed director-type, overseeing a production that's taken on a life of its own.

Considering the on-the-go feel of so many of Winkfield's paintings, it's quite logical that travel is one of his favorite themes. He fills his paintings with things that move — birds, boats, wheels, fish, even pairs of hooves. All these symbols of travel tie into a taste for the exotic and unknown, which Winkfield then domesticates, so that a journey to faraway places also suggests a journey home. The pageant becomes a pilgrimage, and of course there are lots of stories to be told along the way. Among the clearest of the recent travel paintings is *Voyage II*, which, with its wave-like scallops, stylized splashes of water, ship's mast, gull, classical head, and Greek harp, adds up to a fantasy about cruising the Mediterreanean. Here the pilgrimage involves a flashback to the Age of Odysseus.

Voyage II — part of a quartet on the theme of travel, and, at 45 by 72 inches, among Winkfield's bigger paintings — is a grand reflection on the iconography of ocean voyages. It's about everybody's dreams of distant horizons, which are often as affected by advertising brochures as by trips that can be measured in nautical miles. All the dazzling color and procession-like movement may also imply a voyage of life, although Winkfield is too subtle to insist on the Big Theme as anything but a sly aside. The mood is grand yet unaffected. The full tilt, surprising color — which includes ecstatic blues

and oranges in addition to some oddly chilly greens — gives this elaborate conceit a brisk, businesslike esprit. There are elements in *Voyage II* that I can't decode, such as the rows of tomatoes and the ice cream cones. But the strong, left-ward movement of the entire composition carries along even these enigmatic bits. Winkfield knows that this cargo of lunatic fancies will sink if it doesn't swim, so swim it does.

The confounding occurances in Winkfield's paintings are something more than accidents; they suggest a general principle of poetic unpredictability, which we may be more familiar with in the work of writers than of painters. Winkfield would no doubt say that painters can learn from writers (and vice versa); he has devoted much time and energy to editing and translating, and has also written critical essays and prose poems. For some of the artists and writers who first came to know Winkfield a quarter century ago, when he was single-handedly editing an impressive literary magazine called *Juillard*, painter may still seem like only one of the hats that he wears, although I can't imagine anyone doubting that it's the one that suits him best. A look at *Juillard*, whose contributors included the novelist Harry Mathews and the poet James Schuyler, helps to place Winkfield's work within the renewal of interest in Dadaism and Surrealism that was a part of the sixties experience, both for artists and for writers. Edited in England but with the accent on a distinctly New York-Paris axis, the mimeographed *Juillard* was obviously based on some more impressively produced farflung manifestations of the New York School, such as *Art and Literature*, which came out of Lausanne, dashingly typeset and printed on good paper.

The wonderful visual garrulousness in Winkfield's work of the past decade can be traced back to the crosscurrents of art

and literature a quarter century ago. Recalling how he came of age in London in the sixties, Winkfield has written that "everybody. . . seemed to have donned the American aesthetic, and it became absolutely taboo to promote the old bugbear the 'Englishness' of English art. . . . Nobody could see the point of a suburban snow scene when there was Oldenburg to aspire to." But when Winkfield invokes this orthodoxy, which was related to the powerful impact of Pop Art and Color Field painting, he really does so in order to argue against it, and assert the importance of alternative or parallel currents, which included a resurgent painterly realism, a scholarly reexamination of Duchamp, and what Winkfield called, in praising the range of work that his friend Simon Cutts showed at his Coracle Gallery, "the whole kit and caboodle of suppressed Englishness." Some of this eclectic spirit found its way into Winkfield's *Juillard*, which at one time or another included texts by Jasper Johns and a drawing by Fairfield Porter. It was among the more independent-minded spirits of the sixties that Winkfield found friends and supporters, first in England, later in the land of Oldenburg.

Winkfield shares with writer friends such as John Ashbery and Harry Mathews a great enthusiasm for the early twentieth-century French author Raymond Roussel; he named his magazine after one of Roussel's characters, much as another of the little magazines of the period, *Locus Solus*, took its title from a Roussel novel. Decades ago, Winkfield translated an essay of Roussel's, "How I Wrote Certain of My Books," and more recently, in 1995, he edited a valuable Roussel anthology. One of Roussel's methods of composition, which involved generating plots from the double meanings of carefully selected phrases, probably inspired some of the visual double-entendres in Winkfield's work. Winkfield has a passion for word play that can become visual play; he edited two collections of Lewis Carroll ephemera, including some word

games which suggest logical procedures for generating idiosyncratic sentences. He must like Carroll's multifacetedness, the fact that the inventor of Alice was also a mathematician, a poet, a photographer. Lewis Carroll was a Victorian who

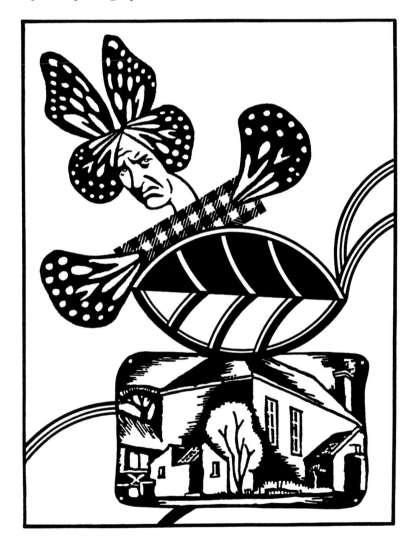

wore many hats, and of course paradoxical headgear is a specialty in Winkfield's work.

And so far as dreaming up weird images goes, Raymond Roussel is in a league of his own. There are passages in Roussel's elaborately bizarre fictions that can almost function as descriptions of the oddballs and panjandrums in Winkfield's paintings. Here are some lines about Le Quillec, the "one-eyed and repulsive" court jester in *Locus Solus.* "To exaggerate his physical grotesqueness," Roussel writes, he "always dressed in pink like the daintiest squire. Witty in repartee, he hid within a comic sheath a good and upright heart." It's possible to image more than one of the denizens of Winkfield's canvases as relatives of the one-eyed Le Quillec. There is the boy with the palm-leaf collar in *Tripoli*; the four-armed figure with the upside-down pot of tulips in *Trapping Birds and Bees*; the winged investigator holding the beaker in *The Mermaid's Revenge*; and the yellow-faced gent with the ornithological headdress in *I Will Not Tolerate Such Insubordination From My Pets!* Winkfield presents his wildest imaginings with an imperious austerity that echoes Roussel.

Making pictures tell stories is never easy, and Winkfield has spent the better part of two decades figuring out how to turn an aura of literary fantasy into an immediate visual experience. In the seventies and early eighties, he painted on paper, and could never quite give his intricately plotted emblems a free-standing poetic ferocity. Even after he made his critical shift to stretched linen he was at first overly dependant on black, illustration-like outlines. He also had a tendency to depend too much on black-and-white dappled effects that may have been meant to mimic photomechanical reproduction but did not really engage the eye. When the breakthrough finally came, in 1986 or 1987, it had to do with taking the antinaturalistic risk of edgy constructivist color,

which Winkfield found that he could use to give designs that were sometimes close to dangerously quaint a contemporary theatricality. Winkfield's masks, signs, and emblems gain in ambiguity as they gain in force; their brilliant clarity makes them all the more difficult to figure out.

The daylit mystery is nothing new in art, and Winkfield has drawn from a variety of sources, as recent as Duchamp, as distant as Vermeer and Uccello. Anyone who is seriously interested in Winkfield's work will be able to trace some of these influences. He has helped the curious along, through his work as an editor and author. The full range of his inspirations, however, is something that I don't believe you can know unless you know the

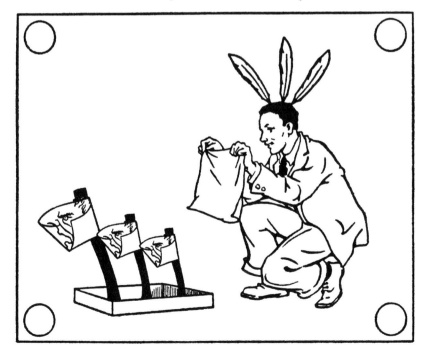

artist himself, and I'm glad that we've become friends—something that does not always happen between critics and artists, even if they are on the same wavelength. We've ended up exchanging enthusiasms, as often for writers as for artists, and Winkfield has urged me to look at the work of a number of literary figures whom I've come to think of as mystery men. Winkfield is especially keen on literary and artistic figures who cut a figure in public while remaining emotionally elusive.

Recently, Winkfield has written essays on Vermeer, perhaps painting's greatest mystery man, and Florine Stettheimer, the American artist who turned Jazz Age Manhattan into her own kind of rococo bohemian enigma. Of course Raymond Roussel fits right in with this group of artists and writers who are both outrageous and enigmatic. So does a figure of the World War II London literary scene, the Ceylonese editor Tambimuttu, founder of *Poetry (London)*. Winkfield, who has of course done a lot of editorial work, loaned me a book of reminiscences of Tambimuttu, a sort of kaleidoscopic collective portrait of an exotic figure who slipped in and out of people's lives, sometimes living splendidly, sometimes barely getting by, but always a dramatic presence. Probably even closer to Winkfield's heart is A.J.A. Symons, the British author, bibliophile, gourmet — and magazine editor — who is mostly nowadays remembered as the author of *The Quest for Corvo*, his study of another literary eccentric, Frederick William Rolfe. A.J.A. Symons managed to live elegantly on so little money that even his brother, Julian Symons, couldn't quite figure out how it had been done when he wrote a biography of his older sibling which might be called *The Quest for A.J.A.*

When Winkfield gave me a xeroxed copy of one of Julian Symons's pieces about his brother, he called my attention to a photograph of A.J.A. Symons who, seen in profile, looks like

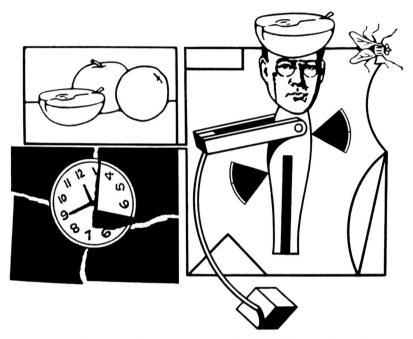

an extremely attractive, overgrown child. He's smiling subtly to himself, while holding a small glass (it looks eighteenth century) which contains some rare vintage or delicious *eau de vie*. Winkfield seemed extremely fond of that photograph, and when I thought about it afterwards it occured to me that the man-child's profile, the smile, and the glass are all reminiscent of elements that frequently appear in Winkfield's paintings. That photograph of Symons may or may not have inspired some of Winkfield's iconography, but its inimitable aura of oddity and aplomb, the two sensationally mixed, is something that you find in all Winkfield's best work.

Many of the figures that careen through Winkfield's paintings might be said to be — like Florine Stettheimer, Tambimuttu, and A.J.A. Symons — aesthetes with nerves of steel. So is Winkfield himself, who has gone his own way yet

managed to exert a subtle and (for New York) surprisingly non-aggressive fascination. In the past few years, as the letters and journals of the New York School of the sixties and seventies have begun to be published, I've been amused to find Winkfield make a number of fleeting but engaging appearances. His name comes up at least twice in a recent selection of James Schuyler's correspondence. There is a 1968 letter in which Schuyler is imagining what the poet Ron Padgett is doing. "Answering the phone: it is Dick Gallup. He wants to read you an item from page 41 of yesterday's *Sooner* but you have already cut it out, altered a few words and sent it to Trevor Winkfield." Two years later, in a list of things to do, Schuyler offers these possibilities. "Go pick wild strawberries? Uhmn. Take a photograph? Bleh. Type something up and send it to Trevor? Gmorch. Write John? He owes me a letter." The John is of course John Ashbery, who, in Joseph Cornell's journals, brings Trevor Winkfield along when he visits the reclusive artist in his house on Utopia Parkway in Queens. "11/6/69[.] Ashbery Winkfield visit[. . .] cerise rabbit presented to Trevor Winkfield[.] pink in John Ashbery's shirt — vertically striped[.] raspberry red in the linzer tart."

I'm sure there will be more Winkfield sightings as more letters and memoirs are published. What makes these initial anecdotal slivers so much fun is how they begin to compose a portrait of the artist. It's a veiled portrait that, not surprisingly, resembles one of his own paintings. The clipping from the *Sooner* (whatever that is!), the unwritten letter, the wild strawberries, the cerise rabbit, the pink shirt, the vertical stripes, the raspberry linzer tart make an exciting collage but are difficult to entirely explain. The thrill of the juxtapositions has something to do with the puzzle's not quite falling into place. The quest for Winkfield continues.

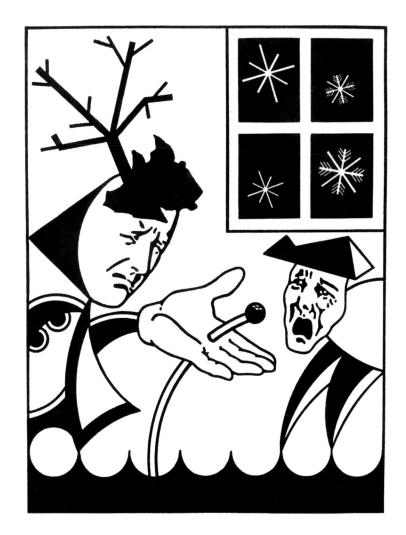

Sixteen Paintings

A Thirty-six Page Rodent, 1989, 43 1/2 x 52 1/2", acrylic on linen

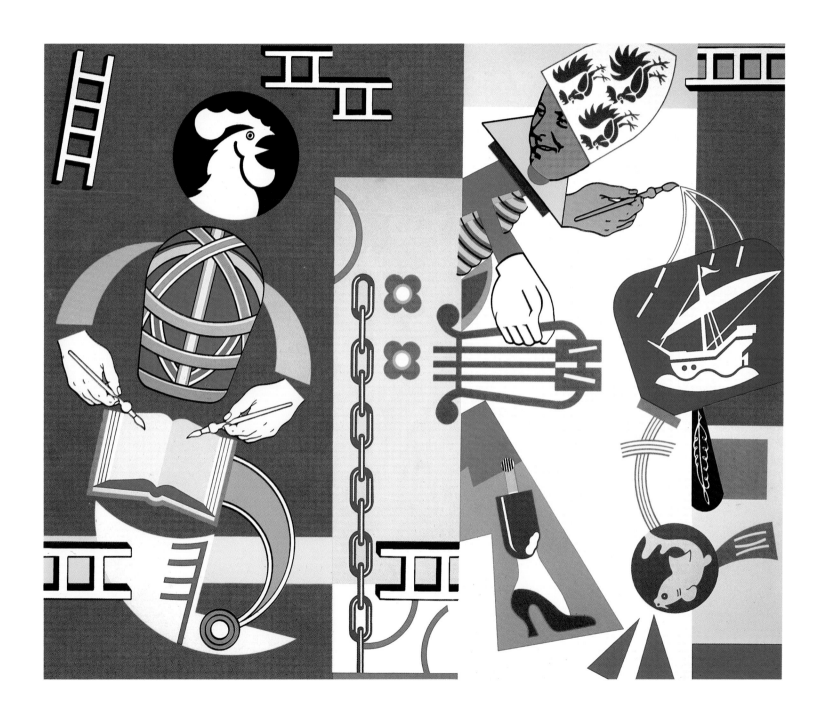

Tripoli, 1991, 37 1/2 x 49 3/4", acrylic on linen

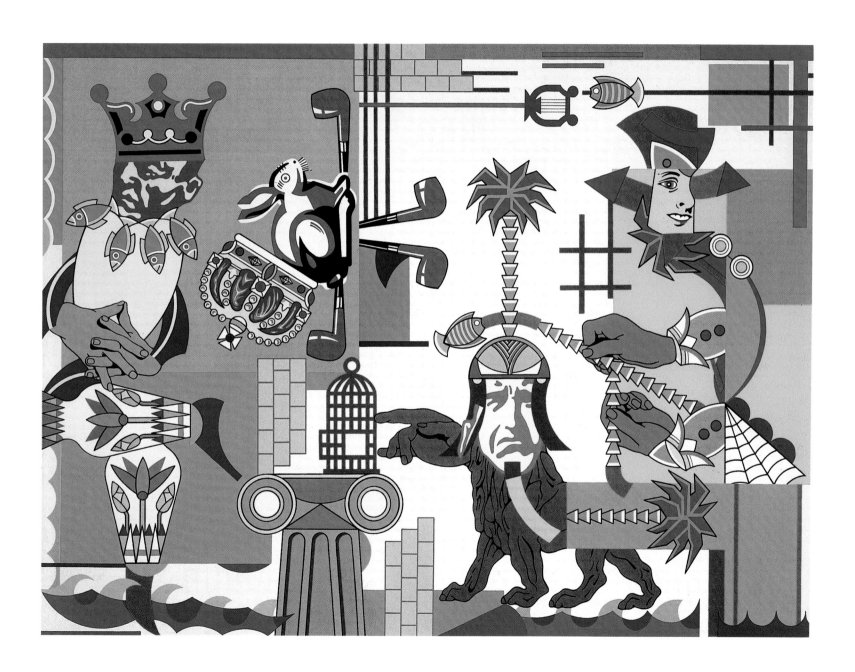

Trapping Birds and Bees, 1992, 47 1/2 x 56", acrylic on linen

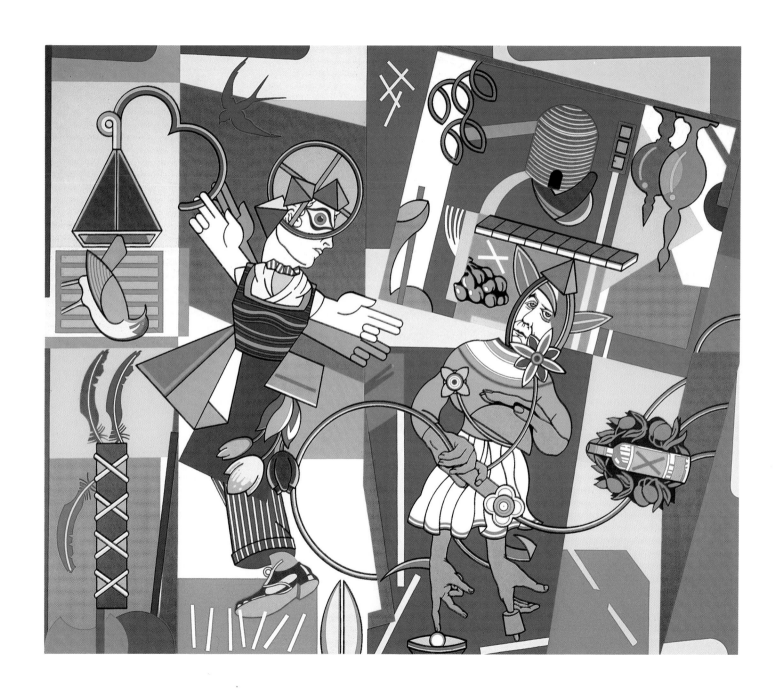

A Winter World, 1992, 49 x 56 1/2", acrylic on linen

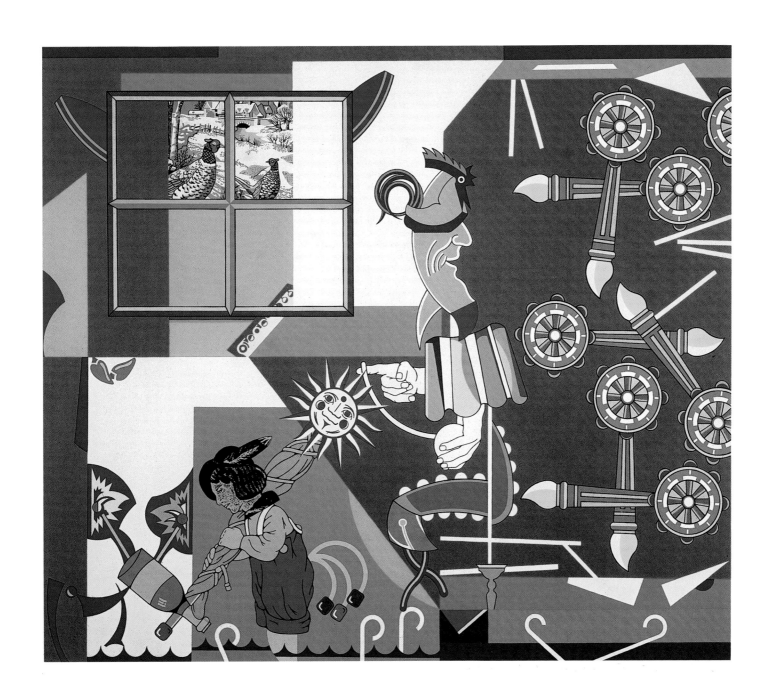

In the Vicinity of a Grocer, 1993, 46 x 54", acrylic on linen

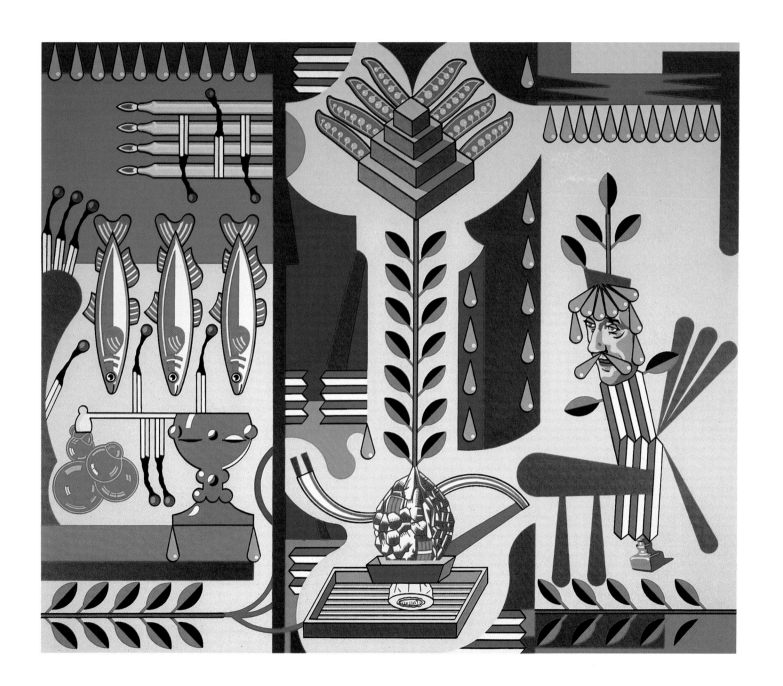

The Mermaid's Revenge, 1993, 44 x 59", acrylic on linen

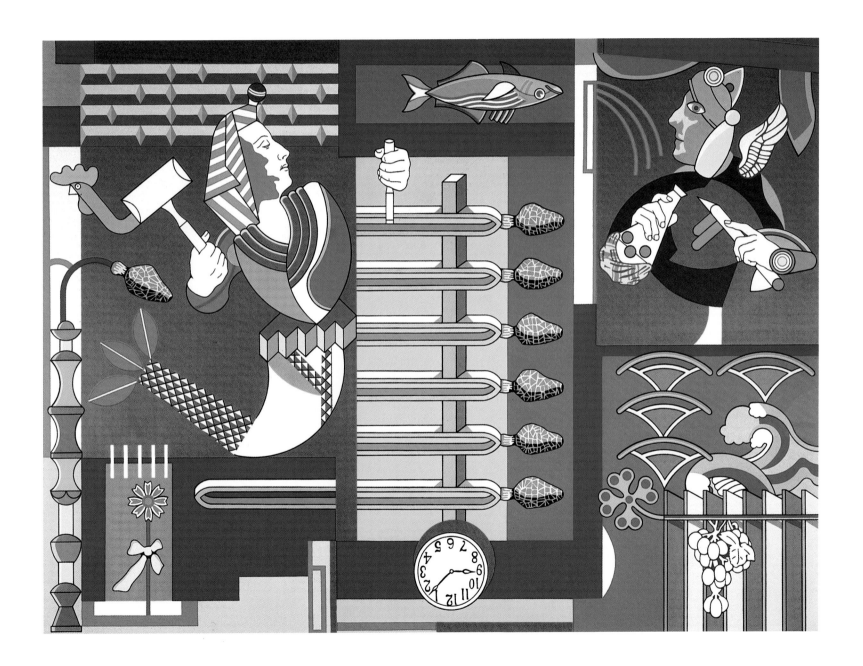

To Market, To Market, 1994, 48 1/2 x 55 1/2", acrylic on linen

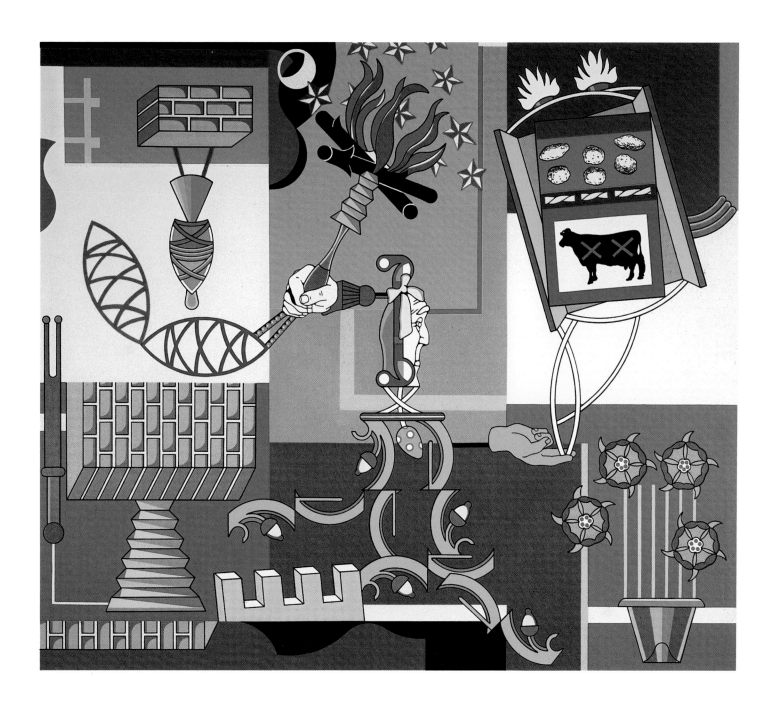

Samson, 1994, 43 3/4 x 61 1/2", acrylic on linen

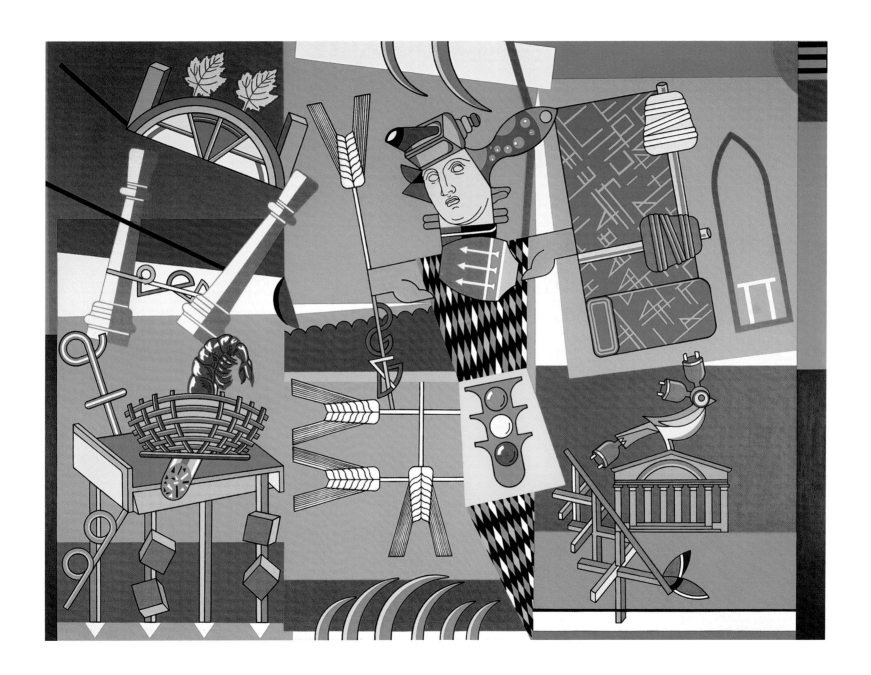

At Home in the Crab Nebula, 1994, 43 x 58", acrylic on linen

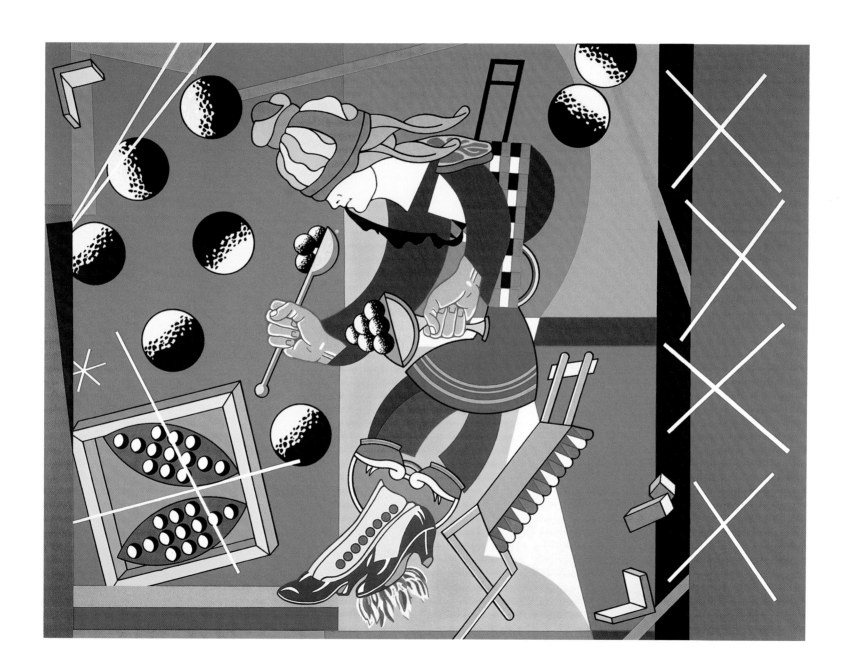

I Will Not Tolerate Such Insubordination From My Pets!, 1994, 48 1/2 x 60 1/4", acrylic on linen

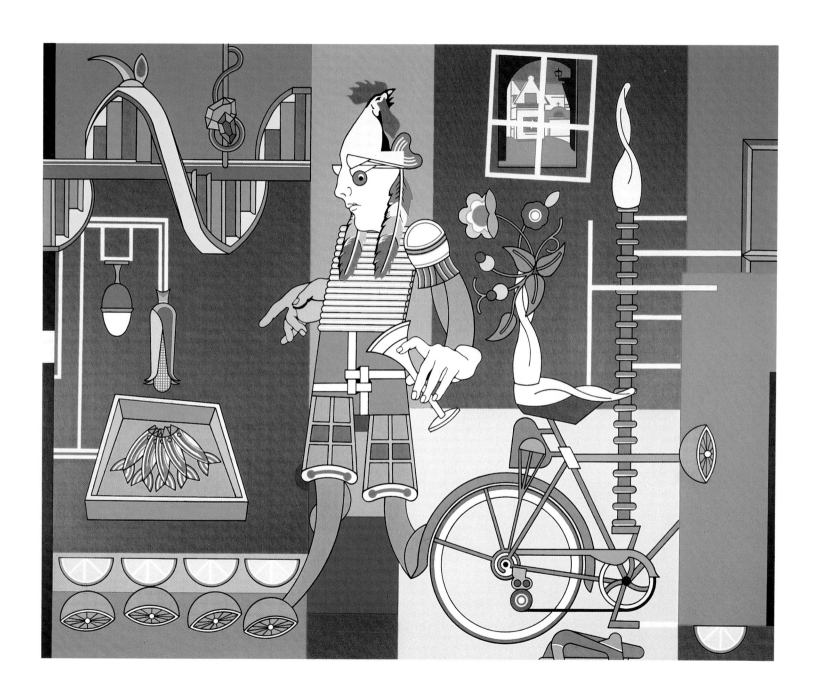

Pond Concert with Blank Cards, 1995, 48 3/4 x 59", acrylic on linen

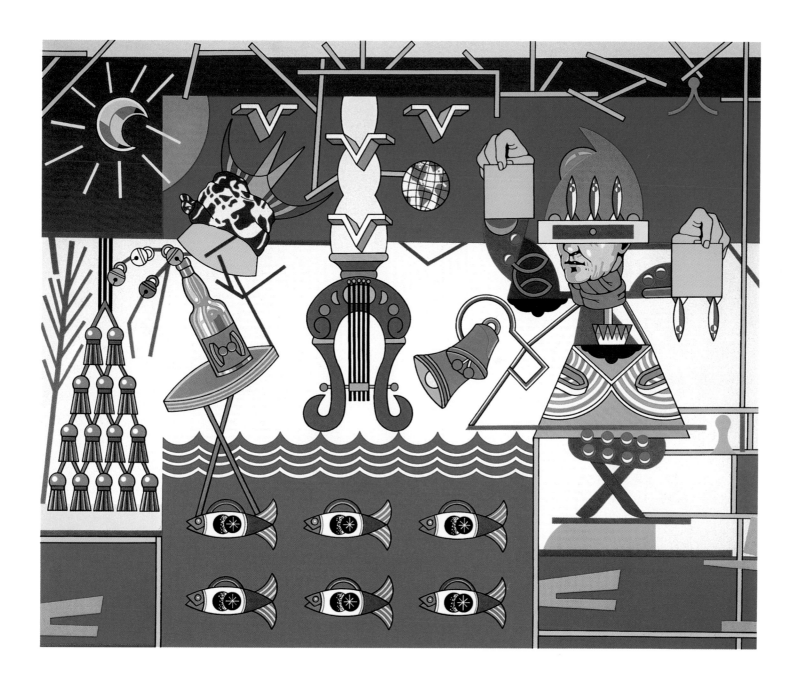

The Painter and His Muse, 1996, 47 x 68 1/2", acrylic on linen

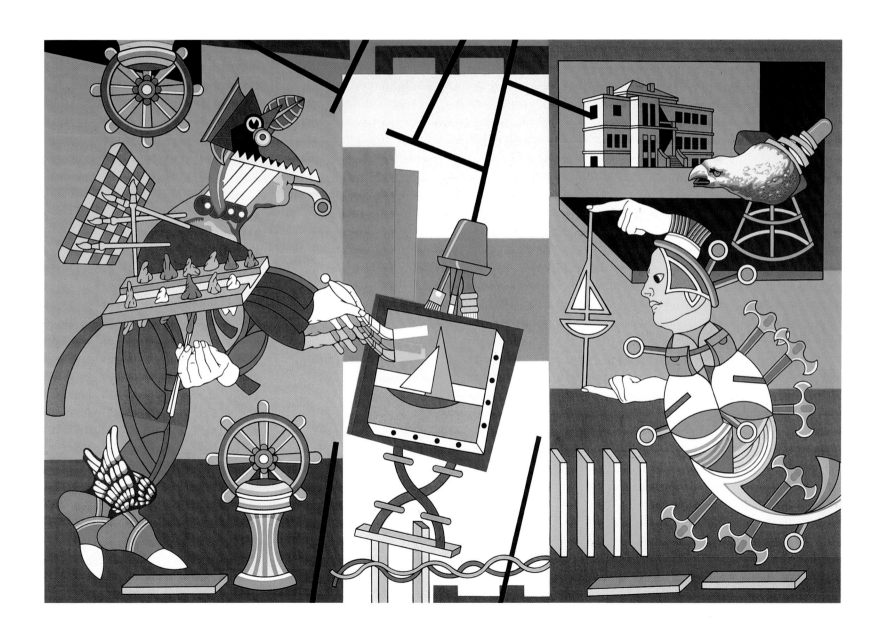

Voyage I , 1995, 45 x 72", acrylic on linen

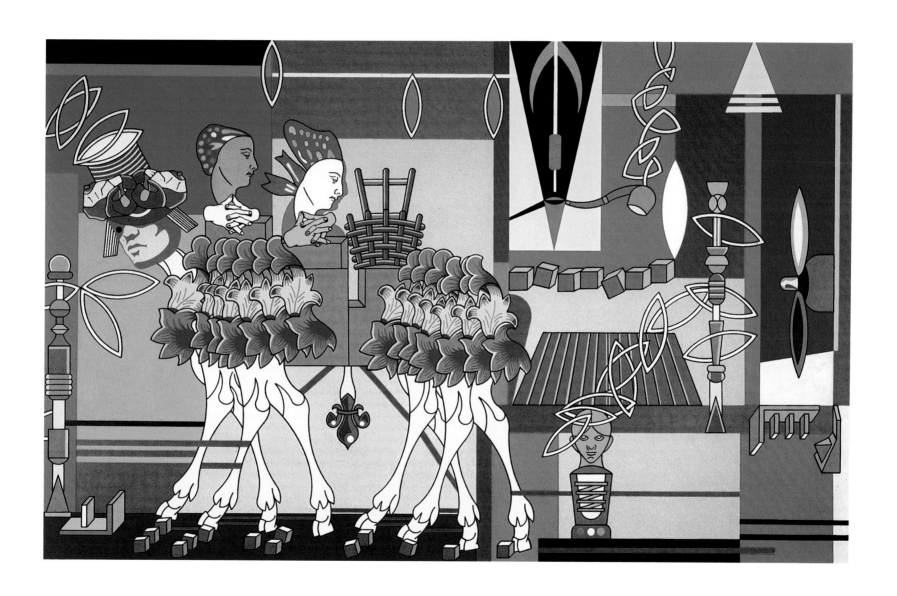

Voyage II, 1996, 48 x 70", acrylic on linen

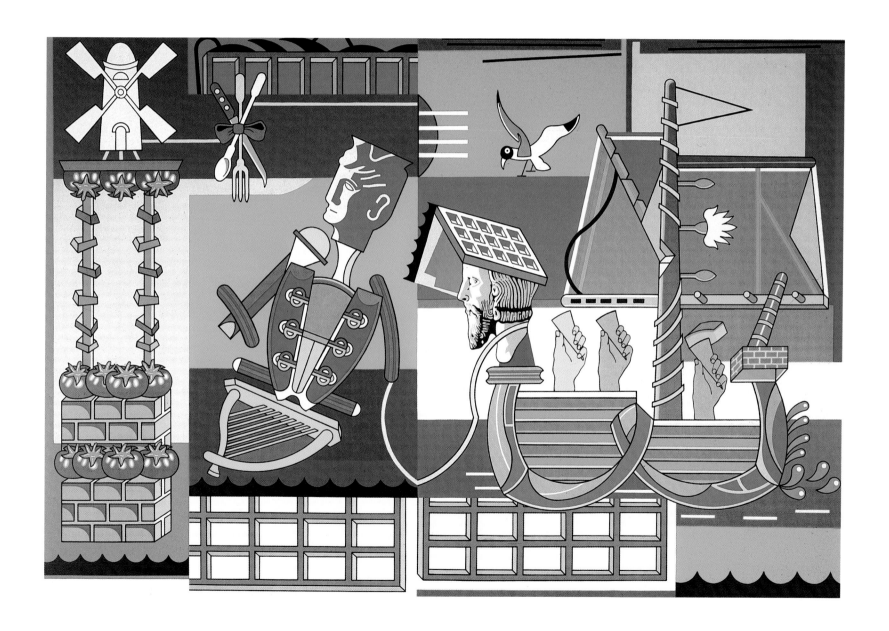

Voyage III, 1996, 53 x 69", acrylic on linen

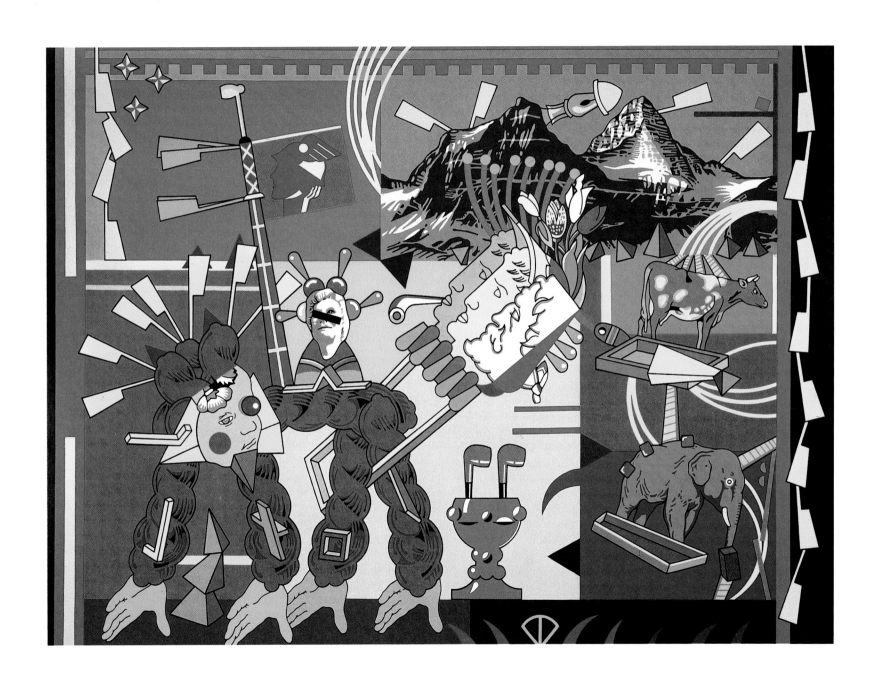

Voyage IV, 1997, 45 1/2 x 61", acrylic on linen

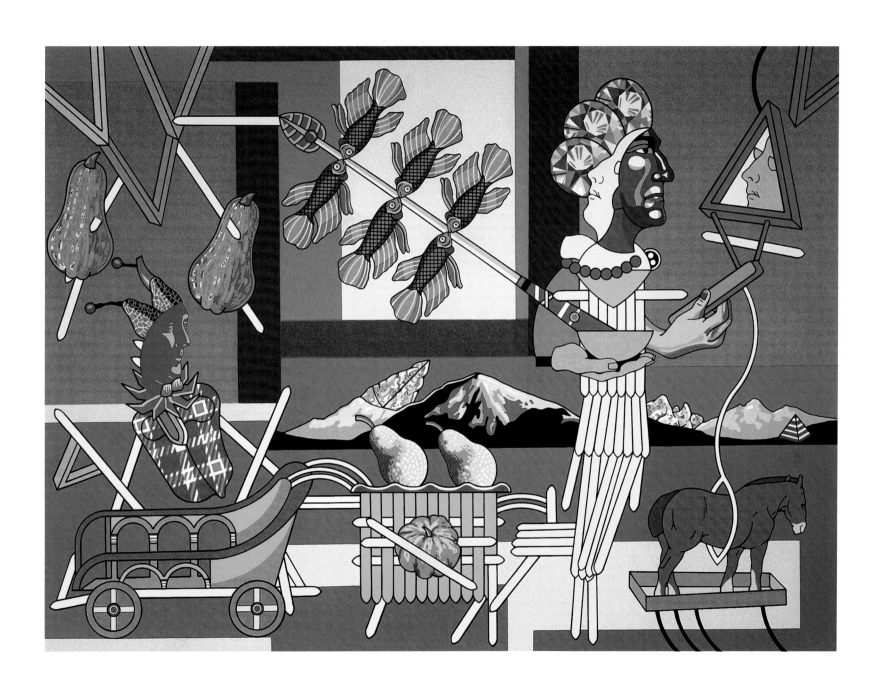

Twelve Daubs Unillustrated

FAMILY

Fenced in by partly pitted peaches and his own blackened hearts, an irate father flings your heart back at you from an outstretched palm on which one of two feathered friends have already alighted.

FATHER AND SON II

Under the aegis of a leering ancestral mug, an exhibitionist father casts his backward glance at a fractured Japanese panel whose memory induces fore and aft incontinence. Having blamed his dog, why should we blanche on seeing this timbered lout bequeath such mucky traits to his Dutch progeny? Certain monochrome flies don't!

IN APRIL AND IN MAY

Evading Winter's unbuttoned bones, a conebearing ex-tutor with testy mien takes wing into the wider grey yonders of Spring, one of whose stored slicings already intrudes.

SCOTLAND YARD

In grid ensemble secured by screws, twinned felons seek egress on two levels from a) leering Scotsman b) reproving cleric top-heavy with doughed dice headgear (the former felon intersects a stencilled turkey, the latter leaps a barrel). More die is cast in the corner, where seashells are quadrants.

STUDIO I

Flanked by fish steaks, muffed gnome sleds oblivious towards encounter with lobster who, arms outstretched, already gobbles that miscreant's orange fundament. Bunny against palette looks on, offers booze and crib shield. Spore and bell fringe.

STUDIO II

Canopied by spores, chops and buttons, a monochrome green trout excretes polychromed paint dollops while exposing its pale innards, its outers emblazoned with more chops. From this piscine easel two brushes sweep aloft meat plate and snail shell, while to the rear a paint trail is about to be forged by a hand-held brush (hand-shaking rabbits frieze below). A sliced light socket, two seashells and a frying pan block this studio's corners.

THE REPUBLIC OF SMALL CHILDREN I

Porcine endeavours attract clogged onlookers... but still the pork disdains the puddle, while familiar mobile homes embroider hems.

THE REPUBLIC OF SMALL CHILDREN II

Edged with mobile homes in the form of duplicated vignettes, two pasture-bound sibling rivals (one sporting a black eye) share a modest repast amidst a turmoil of ostrich feathers, animal parts and face masks with skull, the whole redolent of a conversation piece askew.

HELICOPTER

Rowed counter against counterpanes, an Easter egg accrues a wheelbarrow, a funnel and two tinted bones to form a makeshift helicopter, the whole skippered by a chick across a reflecting pool whose murky depths sprout stalks bearing dice with multiple choices: the 'copter itself.

ODOUR PANTRY

Rouged sun puckers in her fruit cell at the reek emitted by a motheaten mendicant prone to flights of fancy on her right. A couple of birds keel over from this pong, too.

ANNUNCIATION

Amidst the remnants of an orange grove a whiter than white archangel mistakes the gender of a dapper pond dweller and forecasts frogspawn. Bemused, this denizen of the deep asserts his masculine status by sporting a male mask atop his walking stick (the mask wears a dunce cap doubling as a spare propeller from the display above). Optical circlets scattered.

DEPRAVED BUMPKINS AND LESSER WORRIES

Q. What is the difference between the Prince of Wales, a man with a bald head, an orphan, and a gorilla?
A. The Prince of Wales is the heir apparent, a man with a bald head has no hair apparent, an orphan has ne'er a parent, and a gorilla has an 'airy parent.

—Trevor Winkfield

Trevor Winkfield's Pageant

was printed in September, 1997 in an edition of 2000. One-hundred copies are signed by the authors and the artist. Twenty-six copies are signed and lettered and include a collage by Trevor Winkfield.